BROOKLANDS COLLEGE LIBRARY
HEATH ROAD, WEYBRIDGE, SURREY KT13 8TT
Tel. (01932) 853300 ext.343
Tel: (01932) 797906
This item must be returned on or before the last date
entered below. Subject to certain conditions, the loan
period may be extended on application to the Librarian.

DATE OF RETURN	DATE OF RETURN	DATE OF RETURN
-2. OCT. 1997	-3. DEC. 2001	
14. OCT. 1997	22. JAN. 2002	
15. OCT. 1997	11. MAR. 2002	
18. DEC. 199	27. FEB. 2004	
14. MAY 199		
17. NOV. 1998		
-7. JAN. 1999		
19. MAR. 1999		
-9. JUL. 1999		
15. NOV. 1999		
22. JAN. 2001		

AUTHOR HARRIS

TITLE GREAT WORKS OF AFRICAN ART

CLASSIFICATION NO. 709·6

ACCESSION NO. 067294

GREAT WORKS OF

AFRICAN ART

Nathaniel Harris

A Compilation of Works from the

BRIDGEMAN ART LIBRARY

PARRAGON

Great Works of African Art

This edition first published in Great Britain in 1996 by
Parragon Book Service Limited
Units 13-17 Avonbridge Industrial Estate
Atlantic Road
Avonmouth
Bristol BS11 9QD

ISBN 0-7525-1166-1

Printed in Italy

Editors:　　　Barbara Horn, Alexa Stace, Alison Stace, Tucker Slingsby Ltd
　　　　　　　and Jennifer Warner

Designers:　　Robert Mathias • Pedro Prá-Lopez, Kingfisher Design Services

Typesetting/DTP: Frances Prá-Lopez, Kingfisher Design Services

Picture Research:　Kathy Lockley

The publishers would like to thank Joanna Hartley at the Bridgeman Art Library
for her invaluable help.

AFRICAN ART

In practice, the term 'African art' is rarely used to describe works produced in every part of the continent; for example, it normally excludes ancient Egyptian art and the art of the Islamic north. What it does describe is the traditional, mainly tribal art of Africa south of the Sahara, whose power and beauty has been one of the great revelations of the 20th century.

The main centres of this African art are concentrated in a large area of western and central Africa, virtually identical with the tropical rain-forest and the savanna woodlands to the north and south of it. It is of course no coincidence that these are areas in which timber is in plentiful supply, and that the major African art form is sculpture – which means wood-carving almost everywhere, supplemented in a few places by ivory carving or (in West Africa) bronze-casting.

Some of the art produced for African kingdoms can be described as court art, concerned with glorifying the king and providing for his material and spiritual wants; this is true, for example, of the celebrated bronzes cast at Ife and Benin (pages 30-49). But the overwhelming majority of African works are the masks, figures and other cult objects made for use in tribal rituals. It is perhaps surprising that we can respond so fully to their apppeal, since they were never intended to be seen in isolation (whether in museums or photographs), but were part of a larger experience given by dances and rituals, with emotions heightened by drumming, singing and poetic declamation.

Because most African works of art were made of a perishable

material (wood) and were intended for vigorous use, their life-span was relatively brief. Consequently most of the objects now in museums and private collections are no more than one or two centuries old. On the other hand, they are generally links in a chain, belonging to traditions that are much older, and some carvings from recent times have characteristics that are visibly related to those on excavated terracotta (pottery) figures from the West African Nok culture of around AD 500.

With a few exceptions, in traditional African sculpture the head of a figure is always shown as relatively large (roughly a quarter the size of the body), irrespective of the region from which it comes. But few other generalizations about African conventions and styles can be made with any confidence, and indeed the illustrations in this book demonstrate the notable variety of works produced by tribal societies. At the same time, field research has modified earlier ideas about the fixed nature of such societies, revealing that considerable cultural cross-fertilization has taken place between them. As a result, in many societies there is no single, or even dominant, style, and the treatment of an object may vary according to its nature, function or place of origin.

Contacts with other cultures have also played their part in the development of African art. In the 7th century the armies of Islam swept across North Arica, and subsequent Muslim pressure in the Western Sudan drove many tribes to emigrate. Trade routes crossed the Sahara long before the Portuguese began to explore the west coast of Africa in the 15th century. In the centuries that followed, European trade – especially the slave trade – was conducted on a scale that devastated many communities, while enriching and strengthening those peoples (such as the Ashanti) who took part in it as middlemen. Finally, the 'scramble for Africa' in the late 19th century and the colonial era had an even more powerful impact.

Europeans occasionally collected African works of art as

curiosities or for ethnographic research until 1897, when the beauty of Benin sculpture was revealed after the storming of the city; it was immediately appreciated because it conformed reasonably closely to western standards and conventions. But the real breakthrough came when artists such as Picasso sought inspiration from African sculpture (for example in the celebrated *Demoiselles d'Avignon*, 1907) in their efforts to break with the naturalistic or 'photographic' tradition that had dominated western art since the Renaissance. In time, as public prejudices against 'modern art' crumbled, and unfamiliar formal and expressive qualities were appreciated, African art began to be seen with fresh eyes, and ultimately took its true place among the great artistic traditions of the world.

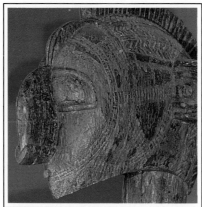

Detail

▷ **Baga mask**

Wood

THE BAGA ARE a small tribe who live on the coast of Guinea; they seem to have occupied the same territory since about the 16th century. This mask, made of wood that has been stained black, represents the goddess of fertility, Nimba. Although very large, it is worn over the head and supported by the shoulders of a dancer during celebrations held after the rice harvest by the Simo secret society; the dancer is able to see through a hole between the breasts, and the attached mass of fibres entirely covers his body. Masks of this type are greatly admired for their imposing air and noble profiles. The large, strong features are carved with a marked feeling for geometry, and elements such as the blade-like nose and the rigid comb of hair are superbly balanced. Standing figures in a similar style are placed as guardians by the road side.

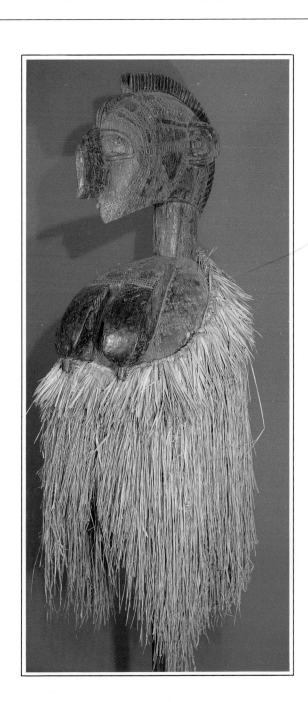

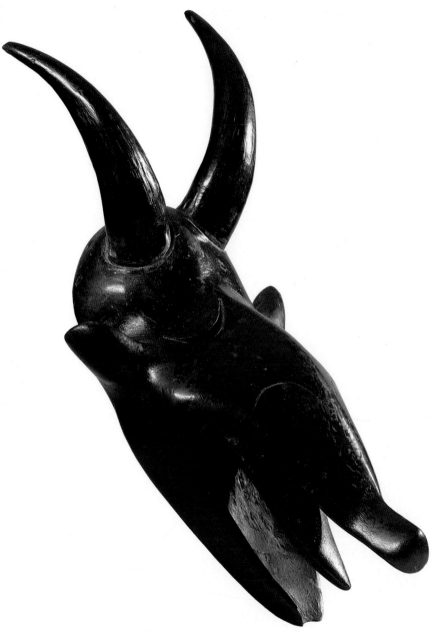

◁ **Dan mask**

Wood

THIS FASCINATING CREATURE is
equipped with buffalo horns, and
traces of red pigment remain on it
to indicate that it was once highly
coloured. The long polished head,
elegantly simplified eyes and ears,
and large tongue are beautifully
balanced. The complex design of
the mask is all the more impressive
when it is realized that the
traditional African artist, unlike his
European counterpart, made no
preliminary sketches to serve as a
guide while he was carving: he
began with an image that had
evolved in his mind, and
constantly monitored the work in
progress, judging it solely with the
eye of experience. The Dan
belong to the large group of
Mande-speaking peoples in West
Africa, and they themselves form a
complex that includes many sub-
tribes. Their area of influence
stretches from Guinea through
Liberia into the Ivory Coast, and
they are closely associated with the
Ngere (page 12).

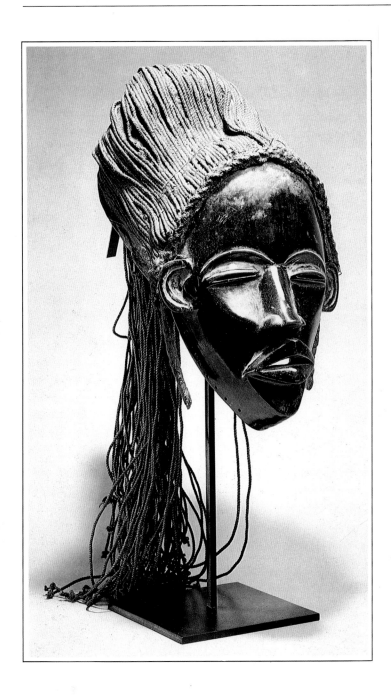

◁ Dan mask

Wood and fibre

AMONG THE DAN and many other African peoples, masks are used for a great variety of purposes: to celebrate the initiation of boys into manhood, to contact ancestral spirits, and even to entertain for entertainment's sake. Moreover the standing of any mask, which is determined by its magical potency, will depend upon local factors as well as upon the type to which it belongs. A mask worn by a high-ranking individual will acquire some of his prestige, and generations of use will also serve to give it an aura of holiness. Many Dan masks have been made for the region's most important institution, the Poro secret society. Like almost all African societies, the Poro is all-male, and this glossy female mask with abundant fibre 'hair' would have been worn by a male performer.

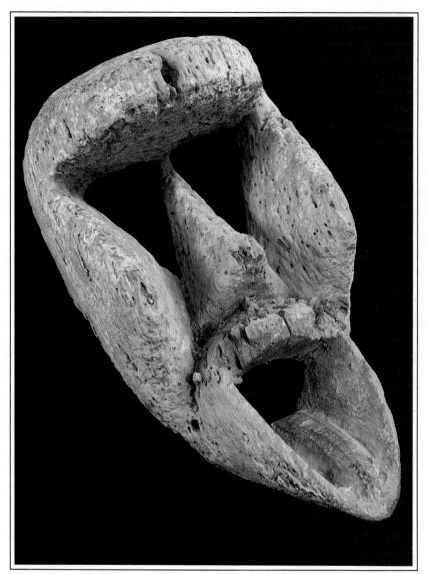

◁ **Ngere mask**

Wood

THE NGERE OF WEST AFRICA are closely linked to the Dan (pages 10-11), and in fact ethnologists often refer to a joint 'Dan-Ngere complex'; among other things, the two groups share a central institution, the Poro secret society. Yet the sculptures associated with the groups are in dramatically contrasting styles, although some individual carvers are said to be able to work in both. The Dan generally produce smooth oval mask forms, whereas the Ngere make strongly structured masks which could easily pass for 20th-century western sculptures and have often been described as cubistic. Their large openings are equally 'modern': as in a carving by Henry Moore, the voids are as important as the solids. However, the strength and power of Ngere masks is emphasized by their distinctively rough finish, giving them an overt emotional force that is rarely achieved by comparable works.

▷ **Bambara antelope mask**

Wood

THE BAMBARA ARE a Mande-speaking people who live in Mali; purists prefer to call them the Bamana. From the late 17th century they had their own states, Segou and Kaarta, which were powerful and prosperous until they were conquered by the Fulani in the mid-19th century. Their art is produced by a caste of smiths, who function as skilled carvers as well as ironworkers. The antelope plays a central role in Bambara beliefs and rituals, representing the *chi wara* spirit, who is said to have been responsible for introducing agriculture into their society. Antelope masks and headdresses feature in both harvest and initiation rituals, but the styles range from the highly elaborate to the severely simple, as here. The mask might almost be the helmet of a warrior (perhaps a Viking), but for the stylized horns that reveal its identity as a composite human-antelope head.

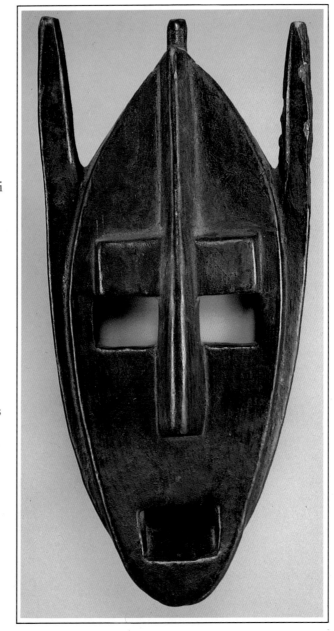

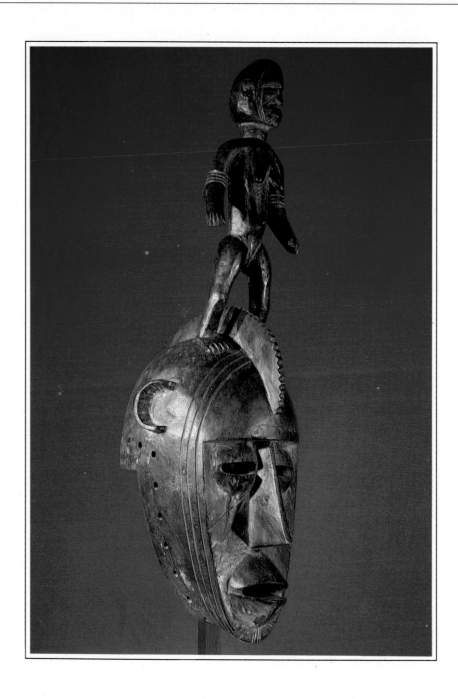

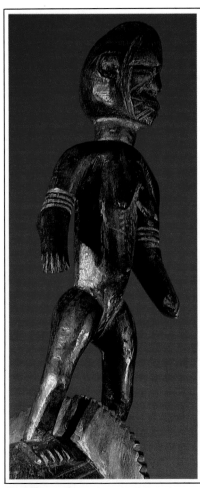

Detail

◁ **Bobo mask**

Wood

THIS FINE ANCESTRAL MASK was carved by one of the Bobo-Fing, or Black Bobo, who live in the border areas between Burkina Faso and Mali. It consists of a face, topped by a superstructure in the form of a female figure with markings on its head, chest and arms. The figure is in a relatively naturalistic style, whereas the face has a strikingly stylized, geometric appearance. Its central area is carved in a flat shield-shape, separating it from the surrounding parts. The main features protrude in blade-like fashion (comb, nose, ears) or bulge roundly (eyes and mouth). Three incised parallel lines run round the side of the face, and there are holes further back, through which a fibre costume could be attached to the mask. Among the Bobo, most of the carving might be painted white except for the protruding features, creating an effect that, to western eyes, suggests intense suffering.

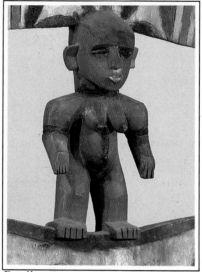

Detail

▷ **Gurunsi mask**

Painted wood

THE GURUNSI LIVE CLOSE to the southern border of Burkina Faso, in the upper reaches of the Volta River. Their neighbours are the Bobo-Fing (Black Bobo, page 15) and the Bwa (Red Bobo), and a number of common elements can be discerned in the art styles of the three tribes. One is the use of masks with very tall, rather flattened superstructures, somewhat resembling in miniature the totems of the Northwest American Indians, at least in the variety and apparent incongruity of their components. However, the design of this mask is unified by the repeated circular 'eyes' and pattern resembling a leaf with two much extended petals. The mixing of abstract motifs with recognizable creatures – a horned animal, a small human female and a large bird head – is remarkably effective. Any impression of incongruity or quaintness is, of course, an accident, created by the disparate visual conventions of the African and western traditions.

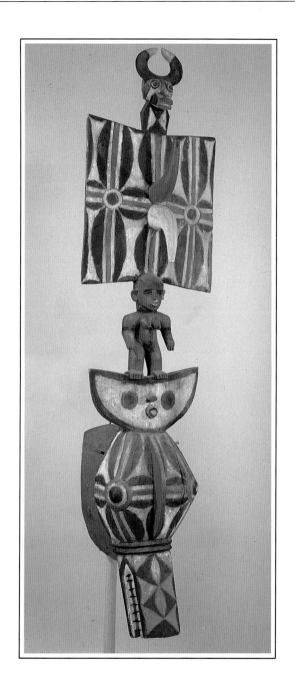

Detail

▷ **Guro mask**

Wood

ONE OF THE MOST BREATHTAKINGLY beautiful of all African carvings, this Guro mask has the characteristic S-shaped face (swelling brow, slightly concave face), zig-zag hairline and solemn, almost sleepy expression. Unlike many African carvings, Guro masks are not designed to be seen just from the front, but are deeply impressive in profile. Guro art was the first African tribal art to be thoroughly researched – in the 1930s, while the old traditions were still strong – and so we know that their masks were intended to be recognizable images of living people, albeit not of the literal, 'photographic' kind; and if the buyer thought that the mask or figure he had commissioned was a poor likeness, or simply an ugly piece of work, he would refuse to pay the carver or bargain to make him bring his price down. The Guro are also celebrated for their loom pulleys carved in human or animal form, and for wonderfully sleek, colourful antelope masks worn by members of the Zamle secret society.

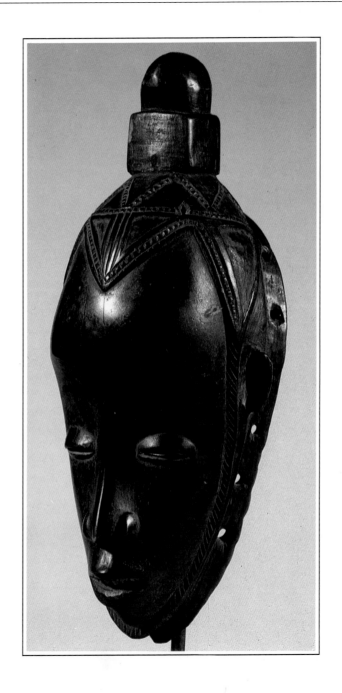

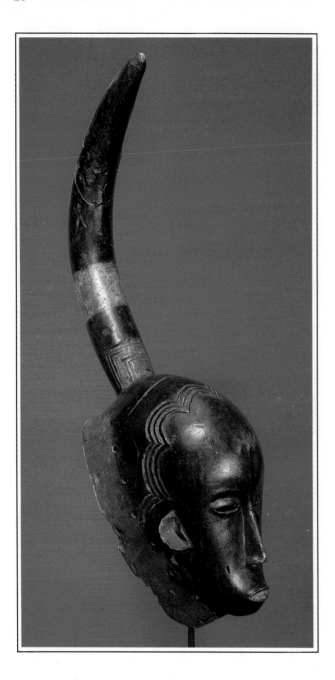

◁ **Guro mask**

Wood

THE GURO LIVE IN the central region of the Ivory Coast; their art has greatly influenced the works of their close neighbours, the Baule (see opposite). The mask shown here is made of wood which was once painted, at least in part, since it carries various traces of pigment. It is a superb example of the refinement and restraint of the Guro style. The head is elegantly sculpted in curves so that the face is slightly concave. The shaved hair line is represented by a series of curved parallel incisions rather than the more common zig-zag shown opposite. The small bumps that can just be made out on the forehead represent Guro tribal scars. The omnipresent theme of curves is completed by the sweeping line of the horn, which is almost certainly a symbol of virility.

▷ **Baule-Yaure mask**

Wood

THE BAULE PRODUCED an art of great distinction, giving their carvings elongated features and a very high polish that emphasized their elegance. Equally characteristic is the meticulous treatment of the hair on the head of the mask, and the details of the bird-figure mounted on it. Many of the tribe's sculptures also carry beautifully executed scar patterns corresponding to those worn by the Baule themselves; and the saw-tooth pattern round the mask, 'framing' it, is also typical. This mask at one time belonged to one of the 20th century's leading sculptors, Jacob Epstein, whose 'primitive' style was deeply influenced by African art. The Yaure are a sub-tribe of the Baule, who live in the Ivory Coast and are themselves part of the Akan group (which includes the Ashanti, pages 22-24).

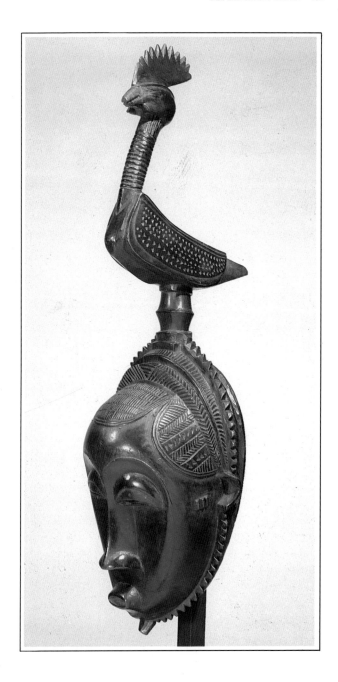

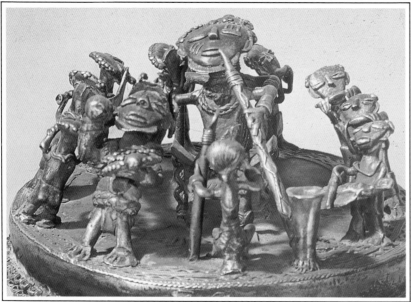

Detail

▷ **Ashanti casket**

Brass

UNLIKE THE TRIBES mentioned so far, the Ashanti people of Ghana created a powerful, highly centralized kingdom, and many of the works made by their craftsmen were luxury objects, designed specifically for the court. The figures on the lid of this sturdy, finely fashioned casket are a king and his courtiers in what appears to be a very relaxed scene. The casket itself was used as a container for the gold dust on which Ashanti prosperity largely depended. Although the body of the vessel has been cast in one piece, the ribbing along its sides, now purely decorative, preserves the appearance of a casket type belonging to an earlier period, when it was made in several sections; this state of affairs, in which a once-functional feature is retained for decorative purposes, occurs quite often in the history of art, and is known as skeuomorphism.

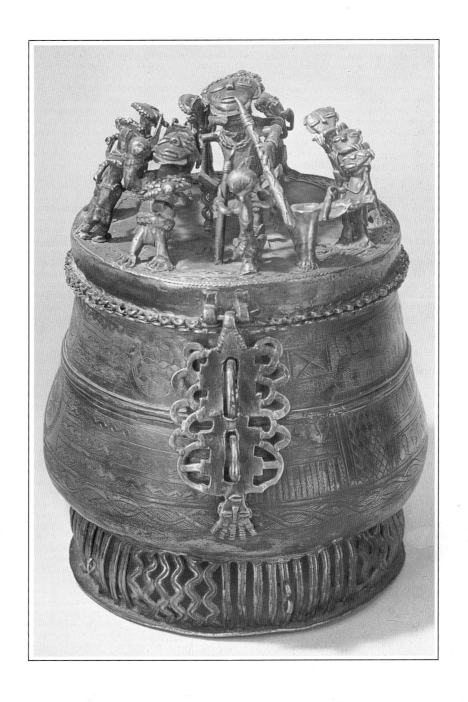

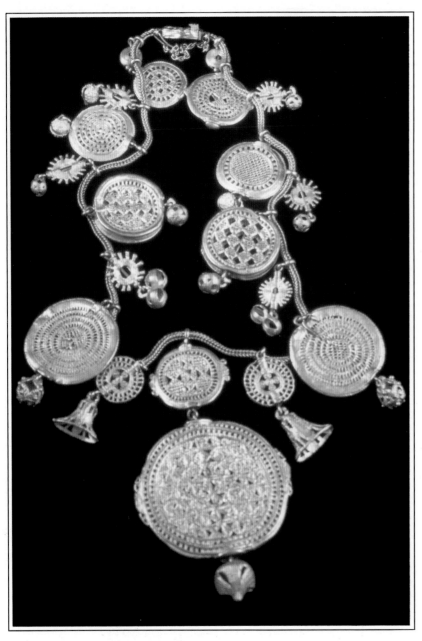

◁ **Ashanti gold necklace**

THE ASHANTI KINGDOM reached
the height of its power in the 18th
century, when this intricately
wrought gold necklace was made.
The Ashanti grew rich by trading
gold with the empires of the West
Sudan, through which the metal
reached North Africa and Europe.
Gold dust was used as currency by
the Ashanti themselves,
stimulating a demand for vessels in
which to store it (page 22) and
weights with which to measure it;
such weights, made of brass in a
great variety of shapes, are now
among the most admired works of
Ashanti art. Other Ashanti works
include terracotta figures and
heads, and wooden dolls with flat
disc heads and rudimentary
bodies. The wealth derived from
gold and, later, slave-trading
enabled the Ashanti kings to build
an impressive capital at Kumasi
and, having acquired muskets, to
maintain their independence
down to 1901, when they were
conquered by the British.

▷ **Yoruba figures**

Painted wood

THE YORUBA NUMBER 12 million or more people, living in south-west Nigeria, Benin and Togo. They have a long history as prolific carvers, bronze and iron-workers, potters and bead artists, perhaps because of their complex social and religious arrangements. The Yoruba have been city-dwellers for a thousand years or more, with a capital in which the ruler lived and smaller towns controlled by sub-chiefs or governors; one outstanding result of this situation was the art of Ife (page 30). The Yoruba worshipped a large pantheon of deities, headed by the thunder god Shango, and there were a bewildering number of local and other cults. Not surprisingly, Yoruba art is extraordinarily varied in style and subject matter. These delightful painted shrine figures represent a woman with two children and a man on a horse; their relaxed appearance and colourful clothes provide a welcome glimpse of everyday life.

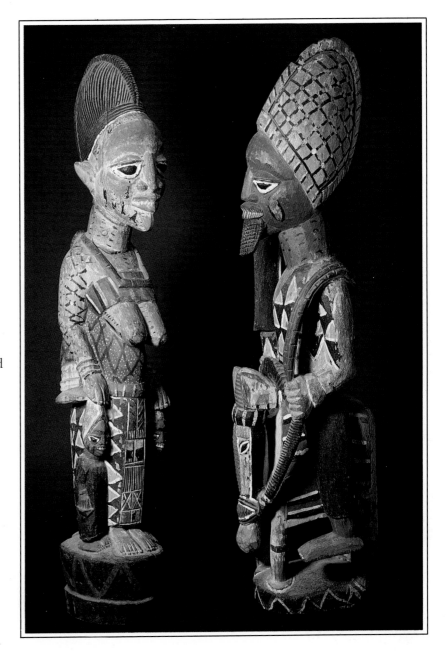

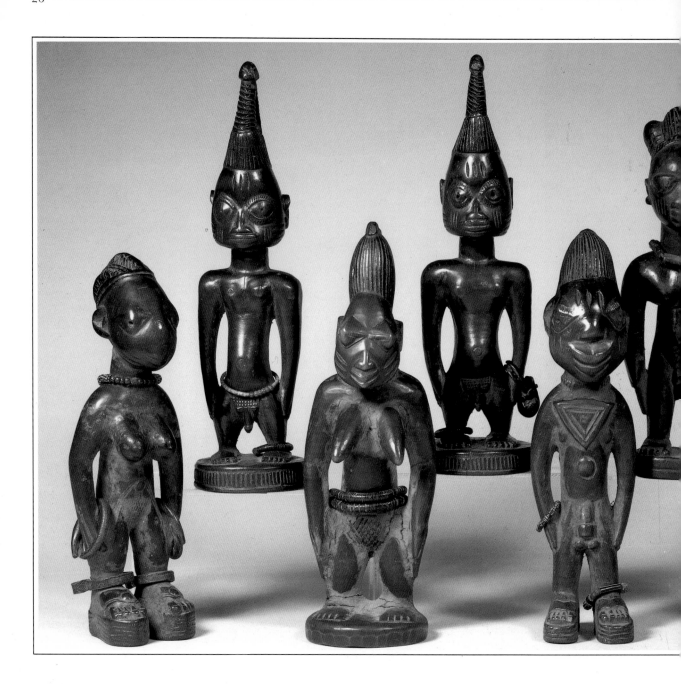

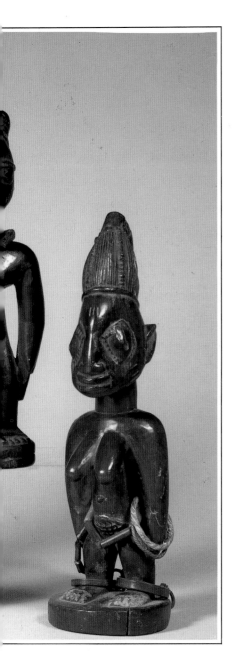

◁ **Yoruba twin figures**

Wood

THE MOST NUMEROUS YORUBA figure carvings are *ere ibeji* figures of the kind illustrated here, which come from Igbominia and Ila. They were made as part of the ritual associated with the birth of twins. Such a birth, apparently duplicating a single being, was regarded as an event of magical significance in many parts of Africa (and, for that matter, has given rise to myths and legends in many lands). The Yoruba are said to have had a particularly high incidence of twin births, and perhaps for this reason developed special cult practices to deal with the consequences. In most cases the *ibeji* was made when one of the twins died – a common enough occurrence in a pre-industrial society. If they wished to escape the wrath of the dead child's spirit, its parents had an image carved which was tended and fed at the same time as the surviving sibling; if both children died, twin *ibeji* were made and looked after in the same fashion.

▷ Yoruba mask

Wood

ALTHOUGH ARRANGED in an unusual vertical design, the three heads on this mask are typical of the Yoruba style in their naturalism; the bottom head might easily pass as a portrait. Yoruba naturalism is mainly modified by the bulging eyeballs and the curious convention by which the lips are carved as parallel lines, so that the corners of the mouth are not shown. This is a helmet mask, designed to be worn on the top of the head during dances performed in secret society rituals. The top two figures, linked in an unusual fashion suggesting that one has grown out of the other, are near-identical and Janus-faced, showing another aspect of the Yoruba preoccupation with duality and twinning (page 26). Traces of red pigment indicate that the mask was formerly painted.

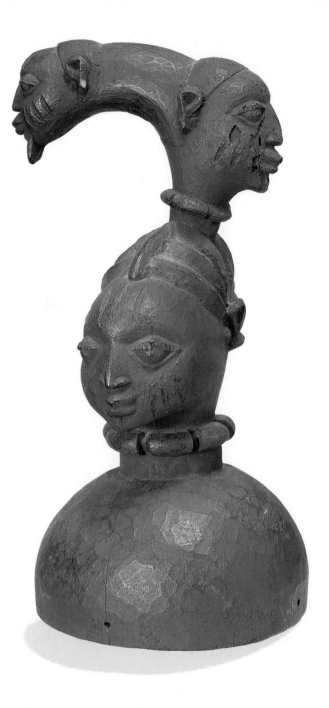

▷ **Yoruba linked staffs**

Bronze on iron rods

THESE 'STAFFS' AND THE CHAIN
that links them are actually ritual
objects, used by the Ogboni secret
society; associated with occasions
on which the society acted as a
court, they were stuck in the
ground so that the bronze parts
remained visible. Known as an
edan, the double-staff features two
human figures and is part of the
cult of the earth spirits to which
the Ogboni is devoted. In the past,
the society had a covert political
role in Yoruba society and might
constitute a rival power-centre to
the court of the *oni*, or king; the
elders of the Ogboni monitored
the behaviour of kings, chiefs and
priests alike, ensuring that their
activities were in line with
traditional beliefs and practices.

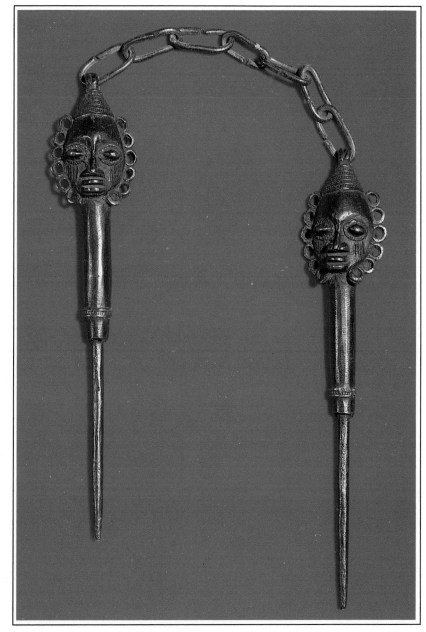

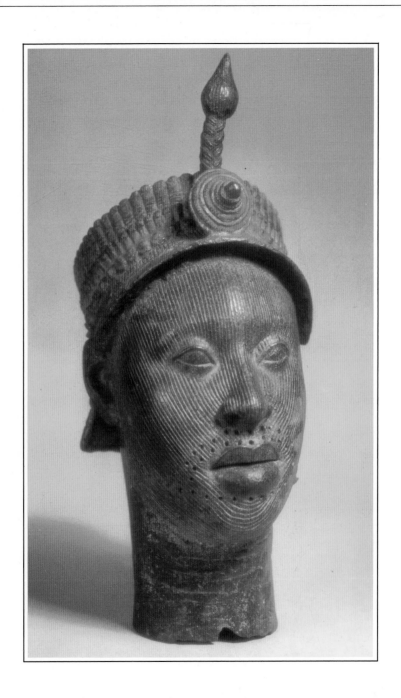

Detail

◁ **Head from Ife**

Bronze

THE YORUBA HAVE LIVED in cities and formed states for centuries. Ife became the chief Yoruba city, retaining its primacy for religious reasons even when its political power was on the wane. Because of its long history, there is still no secure dating for the wonderful bronze and terracotta figures that were uncovered in and around Ife from about 1900; this head, for example, is placed somewhere between the 12th and the 14th century. Even more mysterious are the facts that the bronze-casting technique was very advanced, and that no traces of less-than-perfect Ife works have ever been found. The people portrayed are traditionally said to be the *onis*, or kings, of Ife. The compact form and noble features are irresistibly reminiscent of classical Greek statuary, and one early European scholar asserted that Ife bronzes must have been made by Greeks who had escaped the doom of Atlantis! The close-packed striations are a fascinating feature of a number of Ife works, as are the rings around the neck, still regarded by the Yoruba as a sign of beauty.

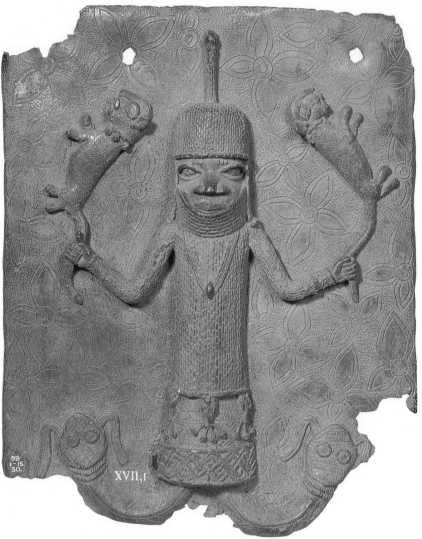

◁ **Benin king**

Bronze

THE MOST FAMOUS OF ALL works of African art are the bronzes made in the kingdom of Benin, which flourished from about the 12th to the 19th centuries in what is now Nigeria; its capital, the city of Benin, still exists. At some point in its early history, Benin acquired the art of casting from Ife (page 30); however, the Bini of Benin must already have had an artistic tradition of their own, since even the earliest Benin bronzes are in a quite distinctive style. Work in bronze was carried out solely for the divine kings of Benin, and so it is a court art rather than a tribal art. On this plaque, the king, or *oba*, is engaged in a leopard sacrifice, an act performed at his coronation and once every year when he ritually renewed his divine powers. By a curious convention, the *oba's* legs are represented as mudfish; this equated him with Olokun, the god of the waters, emphasizing his universal lordship. The pattern of four-leaf symbols in the background is commonly found on Benin plaques.

▷ **Plaque with king and attendants** Benin

Bronze

THE CENTRAL FIGURE in this scene is one of the warrior kings who made Benin great in the 15th and 16th centuries. Esigie won a civil war against his brother, who contested his right to the throne, and then marched against the Igala people who were attacking Benin across the Niger River. The danger was evidently serious, and Esigie's final victory passed into legend. At the beginning of the war, a bird (in Benin belief gifted with prophecy) is said to have cried out that disaster would follow. With the insouciance of the born conqueror, Esigie ordered that the bird should be killed and remarked that a man who wished to succeed would do best to ignore prophecies. Here he is being led back in triumph; one of his attendants carrying a bird-topped staff.

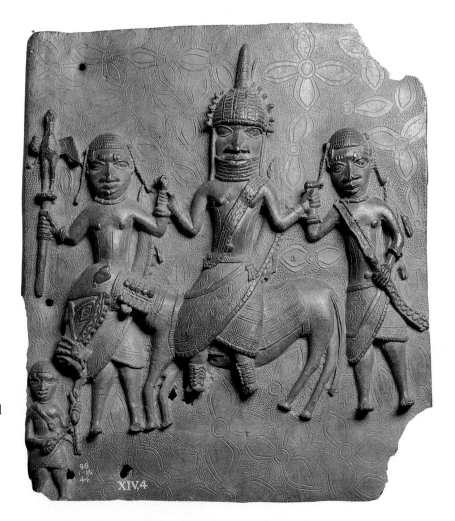

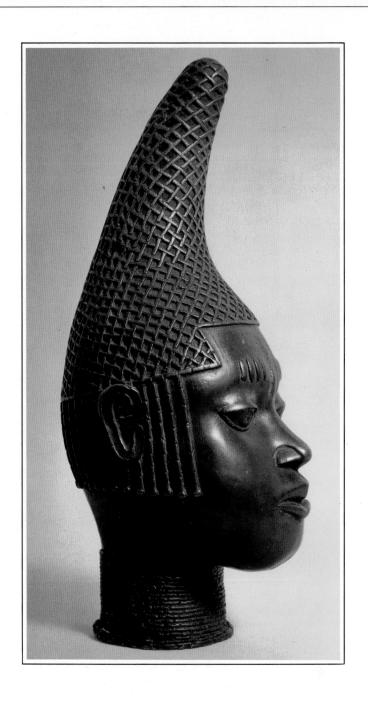

Detail

◁ **Benin Queen Mother**

Bronze

QUEEN MOTHER IMAGES are probably the best known of all Benin bronzes. The Queen Mother was entrusted with the training of the heir to the throne; her position was an official one from the 16th century, said to have been established by the Oba Esigie, whose mother took an active part in the crucial campaign against the Igala (page 33). A series of closely similar Queen Mother images can be found in European museums, as a result of the British storming of Benin in 1897. Hundreds of works of art were looted from the city and subsequently dispersed by being sold to pay the expenses of the expedition. Although the *oba* was eventually restored, the breach in the cultural tradition was never truly mended. Properly speaking, most Benin works of this kind are not bronzes (alloys of copper and tin) but brasses (copper and zinc); however, the convention of calling them bronzes is very well established and, whatever terminology we employ, no one doubts that they have been cast with superb skill.

▷ **Commemorative head**
Benin

Terracotta

AS IN MANY PARTS OF AFRICA, the cult of ancestors was a central feature of religion in Benin, where one of its prime manifestations was the commemorative head. The best-known examples are inevitably in bronze, but they are in a sense untypical, since all bronze casting was done for the exclusive benefit of the royal family. Many more must have been made in wood and pottery, although their perishable nature must have drastically reduced the number of heads surviving from the pre-colonial period. The sturdy terracotta head shown here indicates that Benin potters had a fine sense of form, although their art was technically less advanced than that of the bronze casters. In many instances, for reasons unknown, a head of this type has a hole in the crown; it may well have held an ivory tusk, pointed end upwards, after a fashion known from royal shrines.

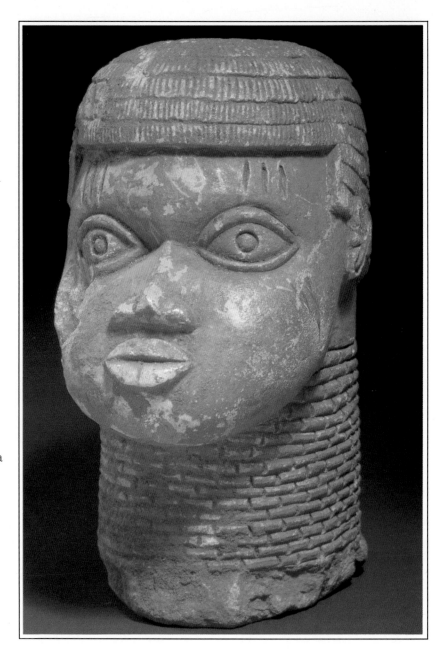

▷ **Benin standing figure**

Bronze

ALTHOUGH THIS IS as fine a work as anything created by the Bini of Benin, it is one of the more mysterious products of their generally well-documented culture. The figure is that of a man, usually described as a messenger, bearing curious 'cat's whisker' marks on either side of his mouth. This and the 'Maltese' cross hanging from his neck are features which, though not very common, are always found together. They do not seem to belong to the Benin tradition and their significance is unknown. Scholars incline to attribute such figures to the influence of neighbouring tribes, and speculate that these may have played some significant part in Benin history which has been forgotten or suppressed; but there is no consensus on the matter. When the Portuguese arrived in West Africa they saw enough crosses to encourage belief in the existence of a Christian state in the interior, and in the likelihood of converting the Bini; but both beliefs proved ill-founded.

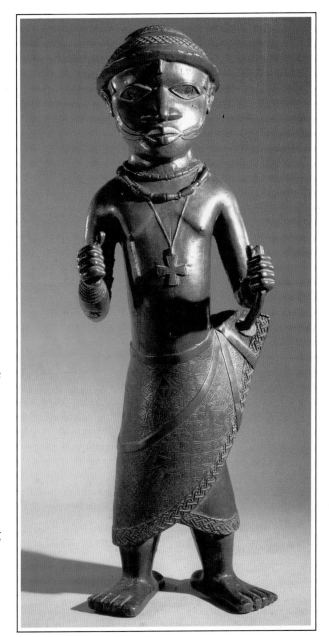

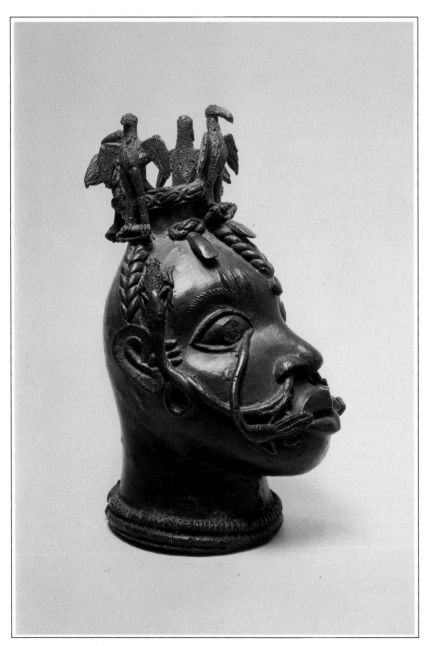

◁ **Benin cult head**

Bronze

AT FIRST SIGHT this might almost be an Indian sculpture of a figure with an extravagant hairstyle and fierce mustachios. A second look reveals that the mustachios are snakes about to swallow toads, and that the 'hair' consists of a ring of birds. Stones and ferns complete the set of significant items which festoon this cult head. Remarkably, they are diminished by its powerful humanity, rather than vice versa. Osun represents the magical forces inherent in herbs and leaves, and has acolytes who use their special knowledge to protect the community against witches, whom the Edo believe to be active and malevolent at night. On this head, the birds are (as usual in Benin lore) prophetic creatures, while the snakes are servants of Osun which the acolyte, as his magical powers intensify, produces from his eyes and nostrils.

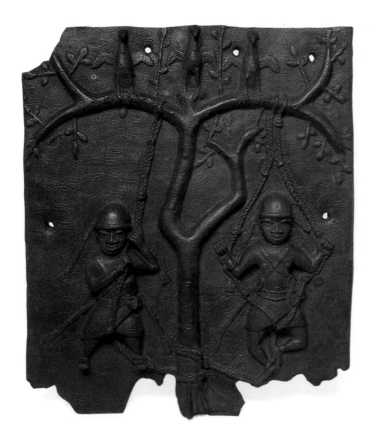

◁ **Acrobats** Benin

Bronze

THE SHOW PUT ON BY these acrobats was one of the highlights of an annual festival, attended by the *oba* of Benin and all the chiefs, which was held in honour of the god of war and iron. The night before the performance, the rope harnesses were unobtrusively put into place in a high cotton tree, the intention being that the audience should believe that the acrobats were flying unsupported through the air, soaring, whirling and plunging in a thrilling 'war against the sky'. Here, a trio of birds supervise the proceedings, but although the scene is stylized and simplified, the artist has enlivened it by varying the details to avoid complete symmetry. Benin festivals were frequent and, although devoted to solemn purposes, good-humoured occasions – except from the point of view of those (mostly slaves and criminals) who were sacrificed for the benefit of the community.

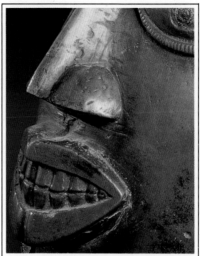

Detail

▷ **Benin mask**

Bronze

THIS IS A HELMET MASK representing the god Uwen, worn at an annual ceremony held to commemorate the foundation of Benin's royal dynasty. Since the *obas* were not merely secular but divine kings, responsible for the fate of the entire people, the occasion was a momentous one. At some time in the past, the elders of Benin are said to have invited Ododua, the king of the sacred city-state of Ife, to choose a ruler for their own city. Ododua sent them his son Oranmiyan, accompanied by the palace gods Uwen and Ora; and the line of warrior kings who made Benin great, as well as all the later *obas* down to the present day, are held to be descended from Oranmiyan. The annual ceremony honours Ododua and involves seven helmet-masked dancers, representing Uwen, Ora and their followers, who dance in front of the current *oba*.

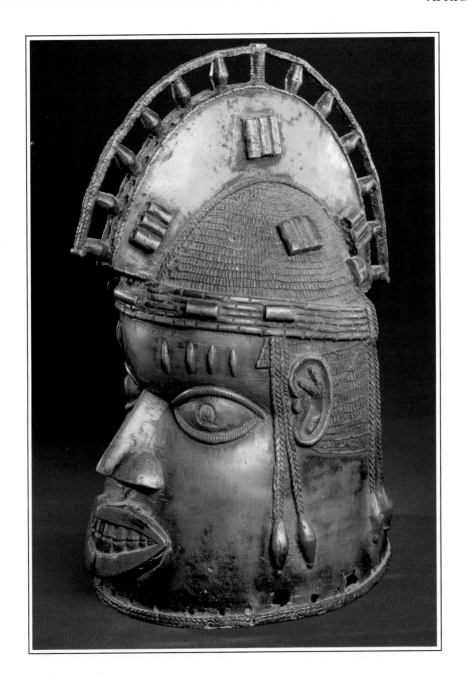

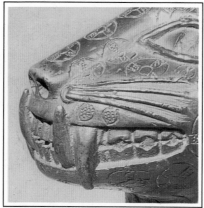

Detail

▷ **Leopard aquamanile**

Brass

THIS SPLENDID CREATURE is an aquamanile, or water vessel, which formerly stood on the altar to the great 15th-century king of Benin, Ewuare. The cross-in-a-circle signs all over its coat are associated with Olokun, the god of the waters. The aquamanile was used only once a year, when the reigning *oba* was making ready for the most important of the annual ceremonies, the Ugie Erha Oba. This is the culmination of a long nation-wide ritual in which the people's ancestors are honoured. In the Ugie Erha Oba, the king performs the same service for his own father, dancing before his altar and making sacrifices to propitiate his spirit. The leopard was a royal symbol, reflecting the belief that king and beast were alike able to strike fear into the heart of an enemy. The leopard hunters of Benin were an élite who jealously guarded entry into their ranks; the bravest and best were said to be able to capture a leopard alive.

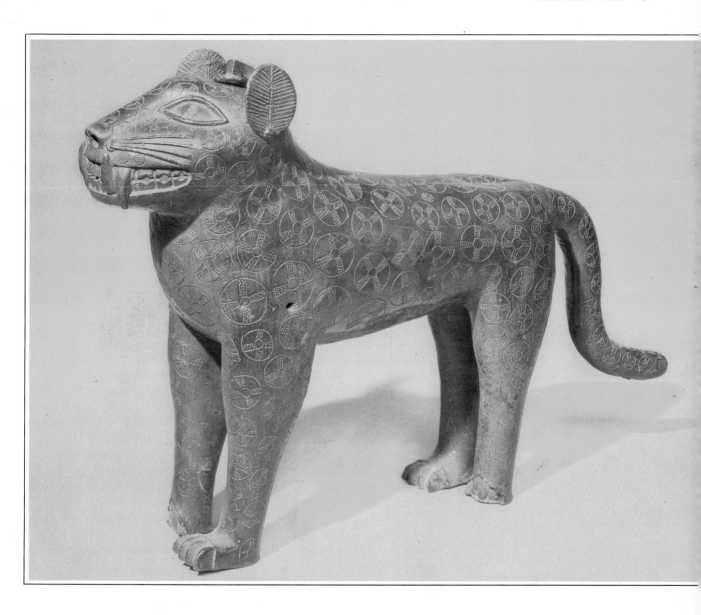

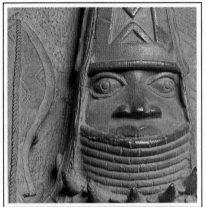

Detail

▷ **Plaque with Benin chiefs**

Bronze

THE CONCEPT OF A PLAQUE with figures in relief was almost certainly introduced to Benin by the Portuguese; it may in part represent a response to European books, with their flat, oblong illustrations. The plaques were attached to the pillars supporting the royal palace in Benin, which was in its heyday a very large, galleried complex of buildings that greatly impressed European observers. The accuracy of their accounts is borne out by the survival of some 900 plaques made of bronze, a metal whose use was exclusive to royalty. The chiefs in this example are clad in a costume made from the skins of pangolins. The pangolin is a kind of ant-eater which defends itself by curling up so that only its tough, scaly skin is presented to an enemy, and presumably it is put on in the belief that it will make its owner invulnerable. A colourful costume, called a pangolin skin but actually made of cloth, is still worn by important chiefs.

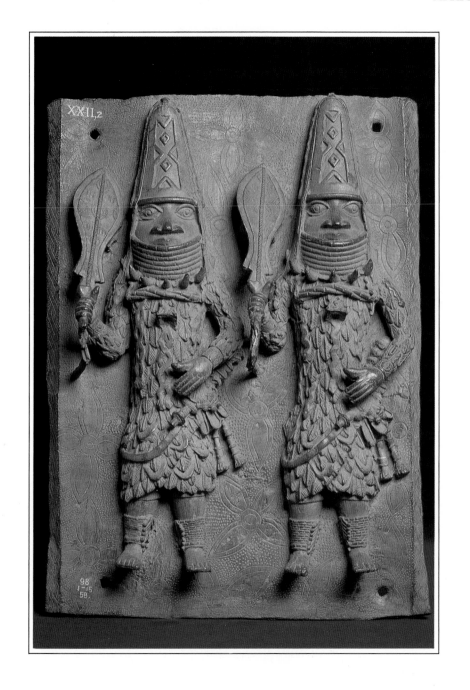

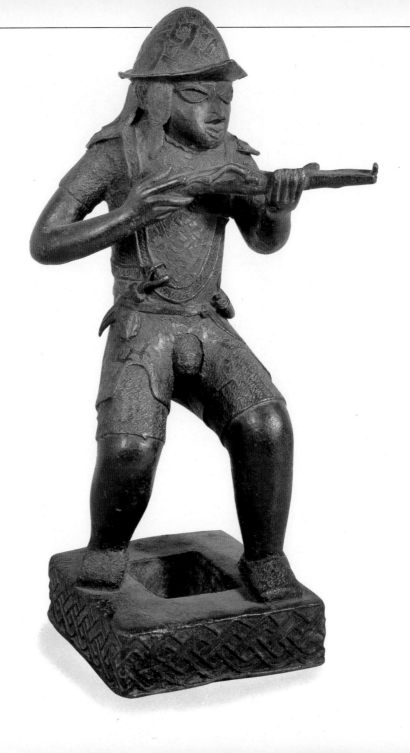

Detail

◁ **Figure of a Portuguese**

Bronze

DURING THE 15TH CENTURY, Portuguese navigators sailed further and further down the coast of Africa, reaching Benin for the first time at some point in the 1470s or 1480s. They found a warlike and prosperous kingdom, with its own currency, and were happy to do business on equal terms, trading coral, cloth and bronze for pepper, ivory and slaves. The impact of the Portuguese on Benin was considerable, and not least on its art: they supplied bronze in quantities and are believed to have introduced the plaque form (pages 44-45). Ivory carving for the European market became a recognized occupation, and Portuguese often appear in examples of traditional art. This figure of a soldier, armed with a matchlock (a kind of musket), probably dates from the 16th century. The style of the figure, with its realistic bent-knee pose, is very different from that in which the Bini of Benin portrayed themselves.

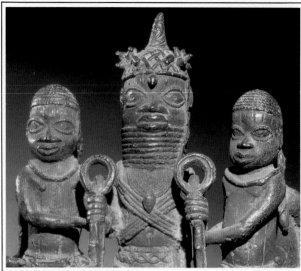

Detail

▷ **Benin shrine**

Bronze

KNOWN AS THE SHRINE (or Altar) of the Hand, this elaborately cast piece was made for the 18th-century *oba* of Benin, Akenzua I, who restored the kingdom after a period of confusion and decline. A shrine of the hand was an accepted symbol of worldly success, made according to criteria that were, for African society, unusually flexible: the individual decided if and when his achievements deserved such a tribute, and then awarded the shrine to himself. Most such shrines were carved in wood, but this example, and one said to have been made for Akenzua's most powerful supporter, were cast in bronze. The top shows the *oba* in all his glory with his followers. The frieze on the base displays the animals he has sacrificed, along with a pair of hands, each giving a kind of thumbs-up signifying the accumulation of wealth.

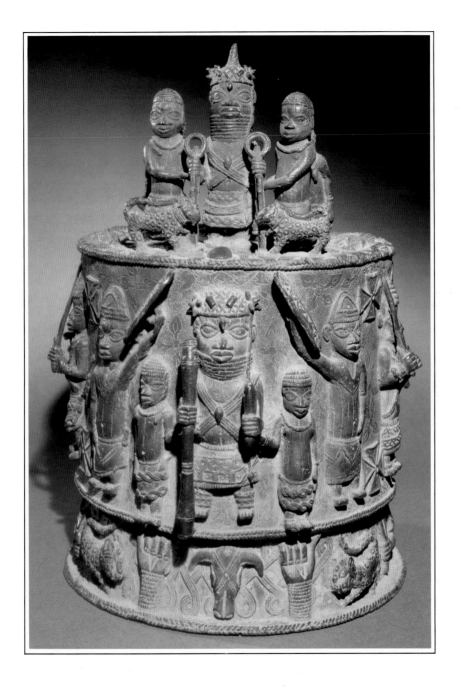

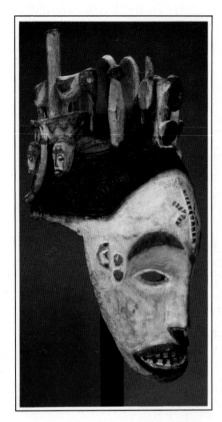

◁ Ibo 'maiden' mask

Painted wood

THE IBO OF SOUTH-EASTERN NIGERIA are known as an intelligent, enterprising people, much given to trading, and their wide contacts have brought many influences to bear on their art, which is very varied. Perhaps their most distinctive works are the masks of the Mmwo secret society which, although described as maiden masks, actually represent dead young wives. Their faces are long and usually white. The star-shaped scarification marks on their foreheads, known as *itchi*, have been traced back some 1500 years, appearing on ancient bronzes excavated in the region. The ornamental superstructure on this mask is particularly fantastic and detailed. As in most of Africa, the Mmwo is an all-male society; dancers who wear masks of this sort also put on close-fitting costumes, with small imitation breasts attached to them, before beginning their performance. The Mmwo also use horned male masks.

▷ Ibibio mask

Wood

THIS FORMIDABLE-LOOKING mask was worn by members of the Ekpo secret society; it is made of a durable hard wood, and its encrusted pigmentation suggests that it was well looked after and passed down from generation to generation. The large Ibibio tribe live in the Cross River area of south-east Nigeria, not far from the better-known Ibo. The figures and masks they carved for use in Ekpo ceremonies represented ancestors but seem also to have been designed to frighten off non-initiates of the society; some were even carved to display all the signs of leprosy or other diseases. The murderous-looking teeth of the face shown here are a common characteristic of Ibibio masks. On the other hand, not all of them have such dangerous smiles, and the splendid spiral decoration is relatively rarely found.

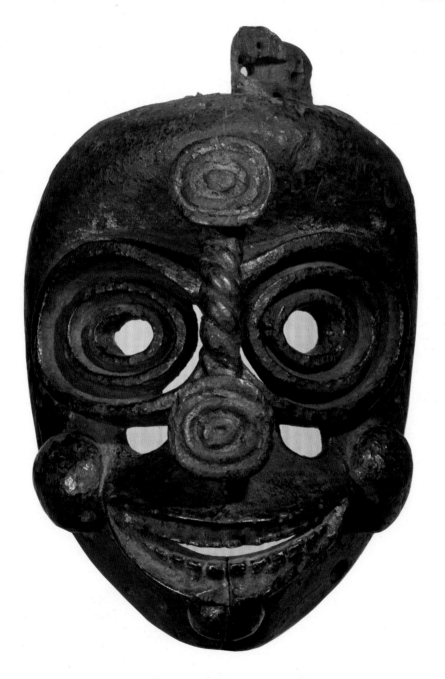

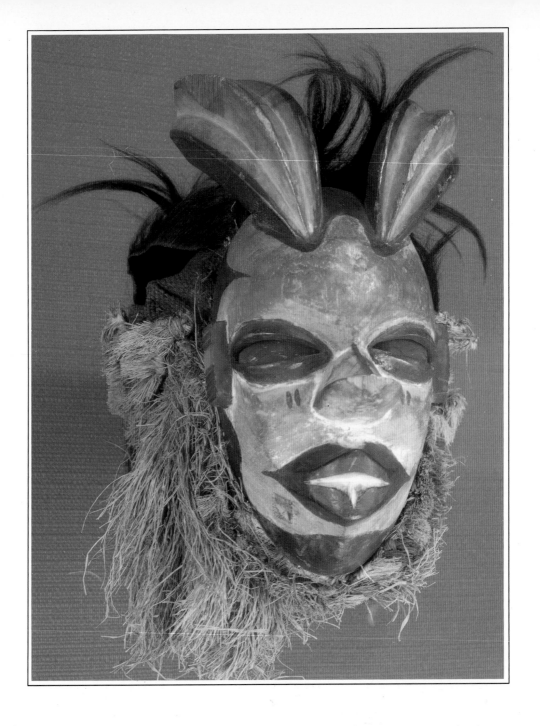

Detail

◁ **Ogoni mask**

Wood, paint, hair and fibre

THE OGONI LIVE close to the Niger Delta in southern Nigeria; their correct name is the Kana, but in the West they are generally known by the term used in the language of their Ibo near-neighbours. The survival of hair and fibres on this mask enhances the effect of its impressively bold features. Like the figures made by the Ogoni, it has distinctively thick painted contours round its eyes and mouth; the double lip-lines are particularly striking. So are the two 'horns' that have been attached to the forehead, since African masks and figures are usually made from a single piece of wood. Ogoni masks probably reflect outside (possibly even European) influence, especially strong thanks to their geographical position. The Ogoni also make animal masks (boars, antelopes, elephants) in a highly imaginative style, close to caricature, which captures the creatures' main characteristics.

▷ **Ekoi headdress**

Wood covered with hide

THE EKOI OF EASTERN NIGERIA
and Cameroon produce
sculptures that have influenced
their immediate neighbours but
are otherwise without parallel in
the traditional African arts. These
are their dance headdresses,
which are carved in wood,
covered with antelope skin, and
painted in a highly realistic
fashion. They represent both
humans and animals, and are
worn on the top of the head
during initiation and funeral
ceremonies. The human heads
are so uncannily convincing that it
is plausible to suppose they were
inspired by a grisly Ekoi custom of
past times – dancing with the
severed head of a slain enemy
strapped to the warrior's own
head: there is certainly something
corpse-like about the fixed gaze,
timeworn skin and protruding
teeth of a typical example. On the
other hand, no hard evidence has
emerged to support the theory
that the skins used to cover Ekoi
headdresses were once taken from
human victims.

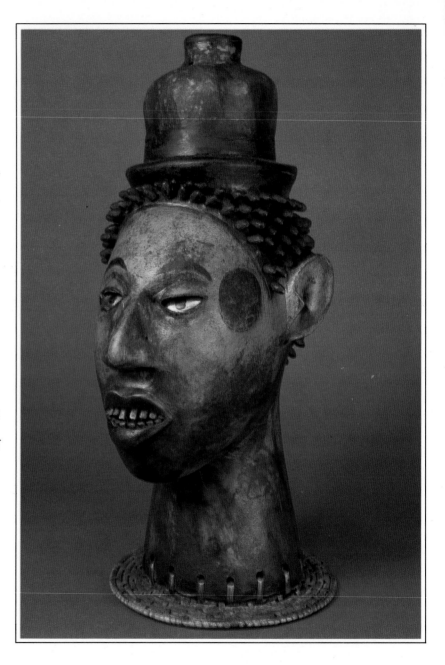

▷ **Fang mask**

Wood and pigment

THE FANG LIVE IN the northernmost area of Gabon, and are well known for their *bieri* figures, fixed into the cylindrical bark containers in which ancestors' bones were kept, and for white-faced masks. This helmet mask is notable for its decorative patterning, and for the four carved heads, each looking in a different direction; although Janus-faced carvings (with faces looking in two different directions) are quite common, the four-way version is rather unusual. The pleasing geometry of the features includes an incised vertical line in the middle of the forehead, curving brows, an arrow on each cheek, and other schematized features. An investigation of Fang attitudes towards funerary art showed that an interesting conflict could exist between religious and artistic values: some people preferred a *bieri* figure that was badly made, but more spiritually potent because it had been carved by a relative of the dead person; while others chose to risk the consequences by employing unrelated but talented carvers.

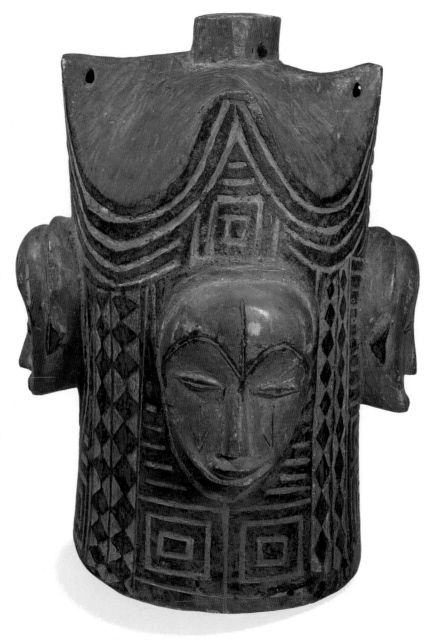

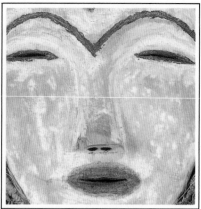

Detail

▷ **Fang mask**

Painted wood and fibre

THE BEST-KNOWN of the white-faced masks are the work of the Fang, although some are also made by neighbouring tribes, often in a more rough-hewn, stylized fashion, with close-set eyes and other features squeezed together in the centre of the face. By contrast, this Fang mask has widely spaced features that give an impression of calm and dignity. The long, double-curved brow line and unpainted 'widow's peak' enhance the effect of simple elegance. The widow's peak also serves to emphasize the fact that the main facial area is heart-shaped, an artistic convention found over most of the northern Congo basin. The white-faced masks represent girls who have died, and are worn during dance performances to reassure the spirits that they are still valued members of the community. The object is to prevent the spirit from feeling resentful and doing mischief; this is a typical response to the belief, widespread in tribal Africa, that women (dead or alive) have special, witch-like powers.

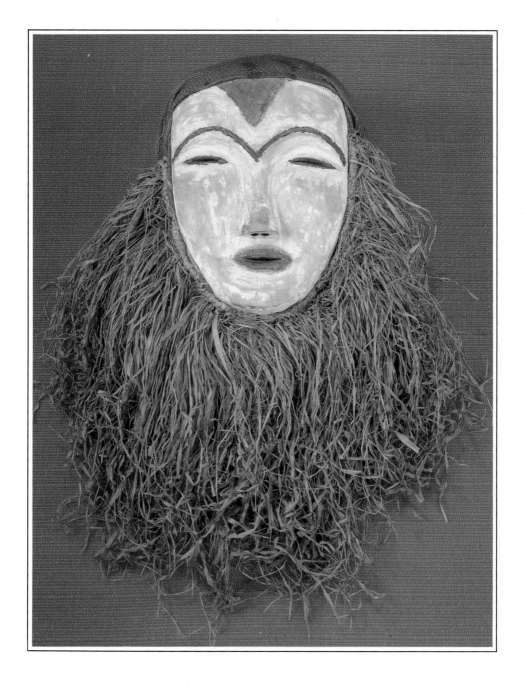

▷ **Bakota ancestor figure**

Wood and copper sheeting

THIS KIND OF NEAR-ABSTRACT figure is found in only one part of Africa, the Ogowe river basin in Gabon. Despite its severe geometry and flattened, two-dimensional aspect, it is perfectly recognizable as a human figure. A copper oval, typically concave, serves as a face, on which the eyes and nose are conveyed by the simplest means. A crescent indicates the presence of hair or a headdress, pegs suggest arms, and the rest of the body consists of no more than a stem and a lozenge. Such figures were attached to the boxes or baskets used by the Bakota to hold the bones of ancestors. They are often called reliquary figures, since the boxes were not dissimilar in function from the containers in which, for centuries, Europeans kept the bones of saints and other holy relics.

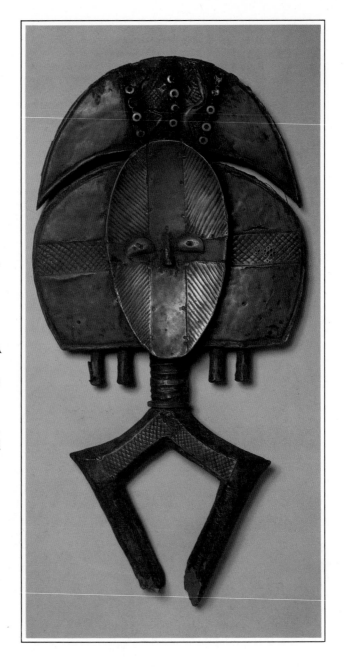

▷ **Ashira-Bapuna mask**

Wood

AMONG THE MOST CELEBRATED of African masks are the 'white-faced' type from Gabon; they were some of the earliest sub-Saharan works to be appreciated and enthusiastically collected by Europeans. This example is made of light wood, with the original white, red-brown and black pigments still much in evidence. Remarkably, the work has lost none of its vitality despite its near-perfect symmetry; even the formalized lines of scarification are schematic, running vertically down the centre of the forehead and horizontally across the temples and nose. White-faced masks represent the spirits of dead girls; the female dancers who wear them sometimes perform on stilts. The masks are found over a wide area, and their exact origins are still a matter of dispute, with many scholars favouring the Ashira or Bapunu tribes in the interior.

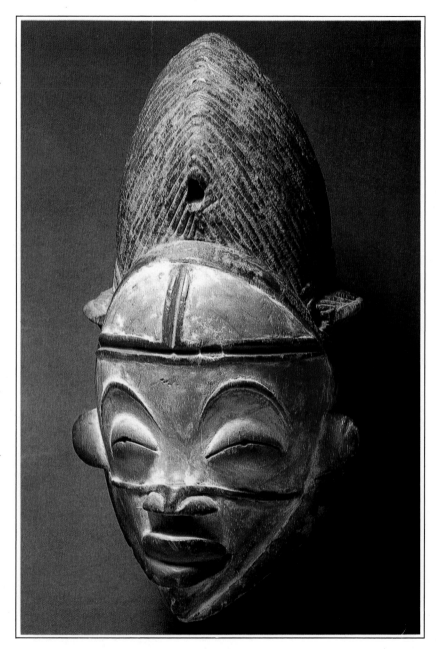

▷ **Basuku mask**

Painted wood

THE BASUKU LIVE by the Inzia
River, in the far south-west of
Zaire. Many African tribes create
a variety of images and types, so
that their masks and figures, for
example, may appear to be
unrelated in style. But the style of
Basuku art is unusually uniform.
Just as they carve the heads of
their figure sculptures so that they
are sunk between raised shoulders,
so they achieve a similar effect on
their masks by burying the chin in
a high, tight raffia nest. Helmet
masks (*hemba*), like the one
illustrated here, are made in a
style of clear-cut simplicity, which
is emphasized by painting them in
one or more stark, flat colours.
Also characteristic is the sleek,
stylized creature standing on the
crown of the mask, the line of its
body perfectly integrated with the
overall design.

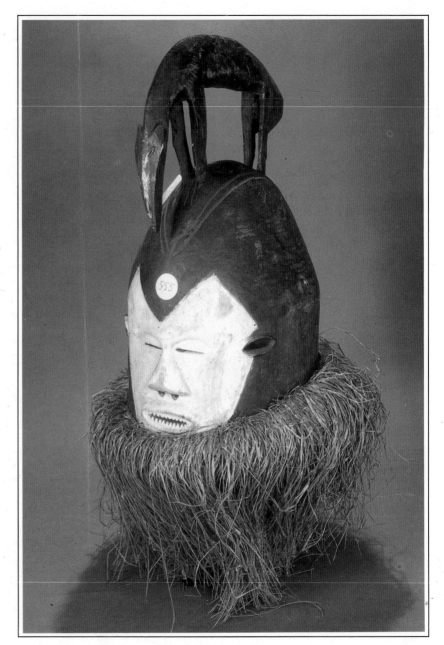

▷ **Bakongo mask**

Wood with pigment

THE BAKONGO ARE a large language group rather than a single people, inhabiting the Lower Congo region (Republic of Congo and northern Angola). The overall style of the Bakongo tribes is naturalistic, and figures are often shown with collar bones (a very unusual feature in African art) and ceramic eyes. In the past, the Bakongo produced many carvings in ivory. However, there are also a number of local styles, including the pot lids of the Bawoyo, which are carved with proverbial scenes and symbols that everybody understands; by selecting the appropriate lid to put over the pot when she serves dinner, the Bawoyo woman can voice an opinion or make a scathing comment without saying a word. Equally idiosyncratic in their own way are the *joango* masks carved by the Bavili, a Bakongo tribe that lives on the Congo coast. This classically simple example has the characteristic open mouth and, even more distinctive, the small tongue carved in relief on its lower lip.

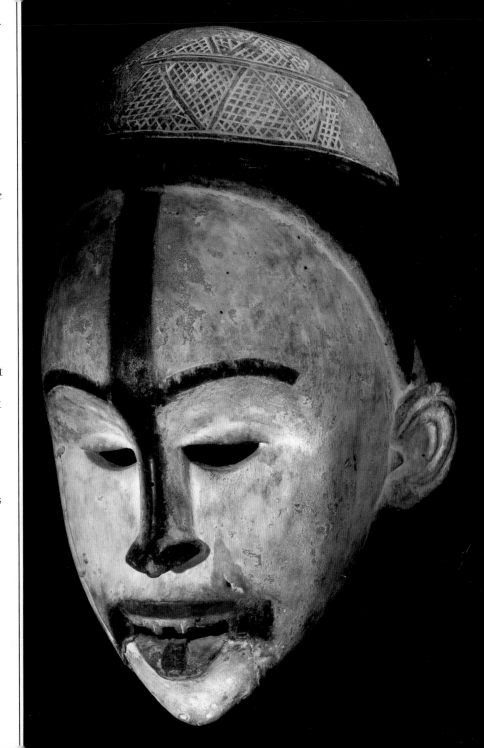

Detail

▷ **Bajokwe mask**

Wood and fibre

THIS VERY DRAMATIC and distinctive mask is the work of a Bajokwe carver. The Bajokwe, or Bachokwe, inhabit northern Angola and some border areas of Zaire. A people with a strong creative impulse, they produced a great variety of intricately carved traditional objects, including masks, figures, staffs of office, pipes, combs, musical instruments, headrests, and chiefs' armchairs based on European models. Here, the long slit eyes and pillar-box mouth are typical of this type of dance mask, as are the exaggeratedly large eye sockets. The studs on the forehead and cheeks represent scarification marks (that is, the raised scars deliberately induced as a form of body decoration). The pattern on the forehead may have some reference to the Christian cross, reflecting the Bajokwe's extended contacts with European slave traders, whom they supplied with chattels.

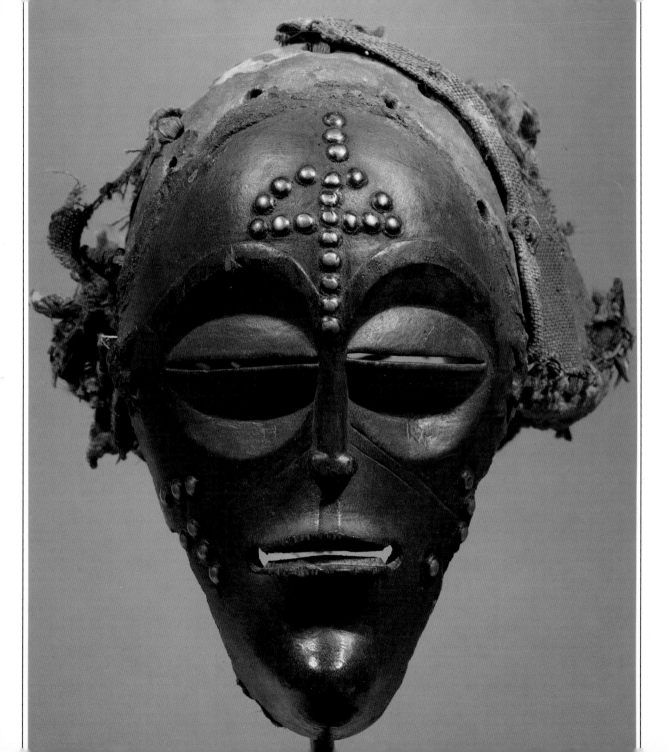

▷ **Bajokwe 'maiden' mask**

Wood and fibre

THIS CARVING REPRESENTS a beautiful girl. The general style is similar to that of the male Bajokwe mask on page 63, with large stylized eye sockets and horizontal slits for the eyes and mouth; but the outline of the face is more fluent and the surface smoother. Traces of red pigment are visible, and a single bone earring is still in place. The scarification marks take an elegant circle-and-loop form on the cheeks, while a simple cross-shaped lozenge pattern appears in the centre of the maiden's forehead. Masks of this kind were formerly used by dancers in initiation ceremonies for boys; the 'maiden' wore a close-fitting costume and wooden breasts. In more recent times, belief in the efficacy of these ceremonies has waned, and such masks have been worn on occasions of public merrymaking, when men and women mimic and mock one another.

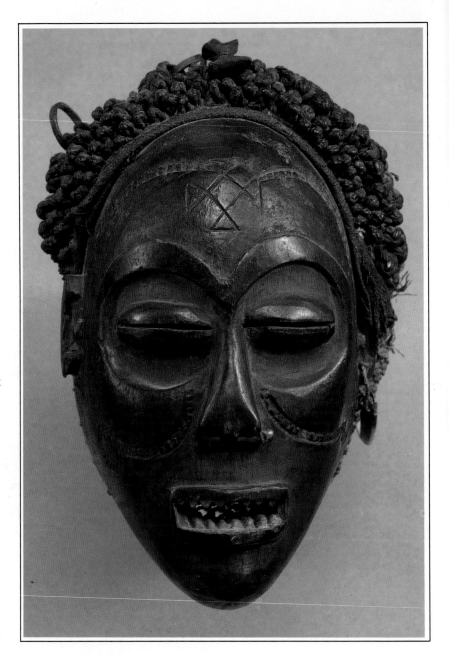

▷ **Bakuba mask**

Painted wood

LIKE THE BAKONGO (page 61), the Bakuba are a group of tribes related by language rather than a single people, although at one time a powerful Bakuba kingdom did exist. The Bakuba use a variety of masks for initiation ceremonies, dancing and other ritual purposes; some of the most colourful are royal masks made from materials such as wood, raffia, beads and cowrie shells. A characteristic of Bakuba heads is the straight, shaven hairline; in the type of mask shown here, it is represented by a long, curved wooden board with wedge-shaped pieces on either side, though a greater degree of realism was achieved by threading raffia 'hair' through the holes in the boards. Other well-known features are the hollow sockets and protruding, rather reptilian eyeballs, surrounded by holes for the mask-wearer to see through; the black-and-white triangular patterns; and the linked mouth and vertical lip-groove.

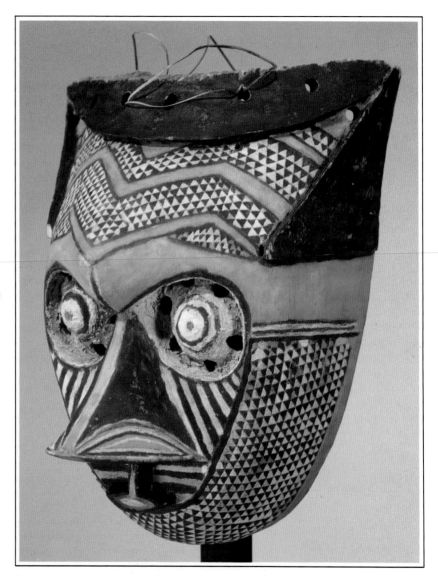

Detail

▷ **Bapende mask**

Wood and fibre

THE BAPENDE OF SOUTHERN ZAIRE are credited by their neighbours with introducing a variety of artistic skills – some of which they themselves have since forgotten. However, they remained highly creative as sculptors, making ancestor and fetish figures, decorating chairs and other objects, and carving masks of many different kinds. This one belongs to the *mbuye* type, used by the western Bapende in the comic entertainments put on when boys have completed their initiation out in the bush; nonetheless it was also filled with spiritual power which enabled its wearer to cope with supernatural forces. The bulging forehead, formalized V-line of the brows, drooping eyelids, pointed nose, high cheekbones and small but prominent mouth are all standard features; the elaborate styling of the fibre hair helped to identify the character represented.

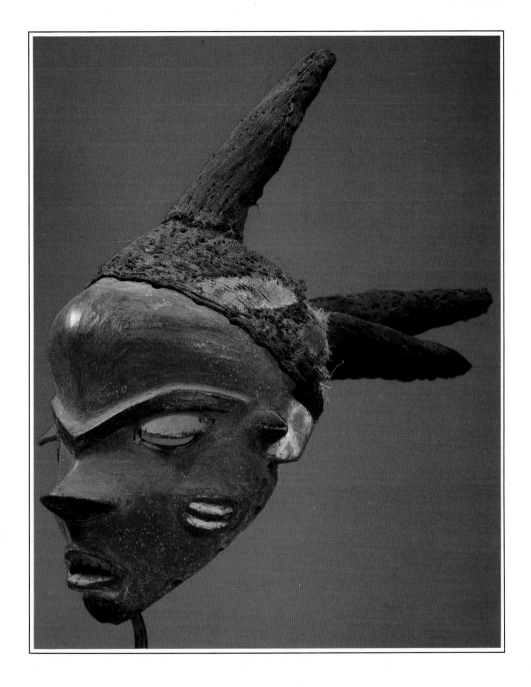

Detail

▷ **Bena Lulua mask**

Wood

THIS CHUNKY, forceful mask comes from the Bena Lulua tribal area in southern Zaire. It is in a very different style from the figures carved by the Bena Lulua, which are relatively slender and refined in feeling, with elongated necks. But there are a number of shared characteristics such as the drooping eyelids and pronounced sockets. The elaborate scarification marks are also found on both figures and masks, most commonly painted on the latter; here, however, they are more realistically carved in relief, their unusual variety of shapes including a strange second mouth, quite different from the main one above it. The 'widow's peak' hairline of Bena Lulua masks is particularly pronounced; the impulse to schematize the markings on the face has proved so strong that the front segment of the hair has been separated from the rest to form part of a forehead pattern with the scarification marks.

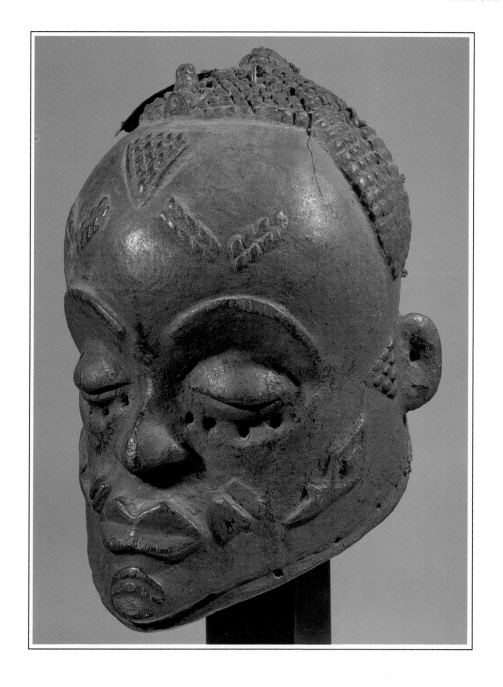

▷ **Bayaka mask**

Wood and cloth

THE BAYAKA ARE the most celebrated carvers of southern Zaire. The face on this initiation mask is typical of Bayaka art, with a tip-tilted nose that in this instance curves right back like a tusk or elephant trunk, the 'framing' of the central area of the face, and the slit mouth that might be taken as expressing contempt. Initiation masks are worn when boys have completed their rites of passage (including circumcision) into manhood at the 'bush school' and returned to their village. As part of the celebrations they dance in front of the villagers, keeping their masks in place by holding the projections under them. The atmosphere is humorous rather than solemn, and the mask may be enlivened by the addition of grotesque figures. Here the superstructure, made of cloth over a basketwork armature, represents a house.

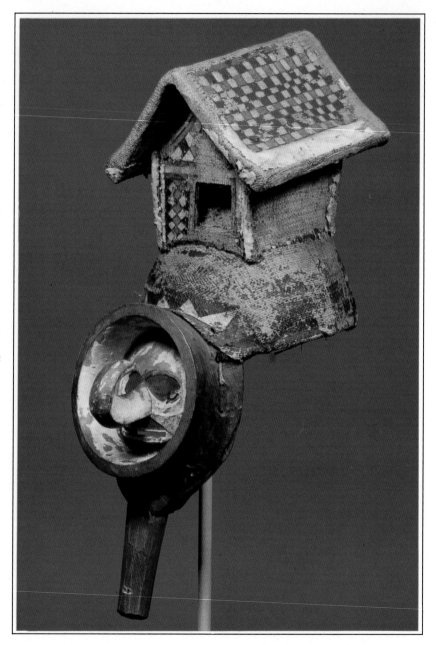

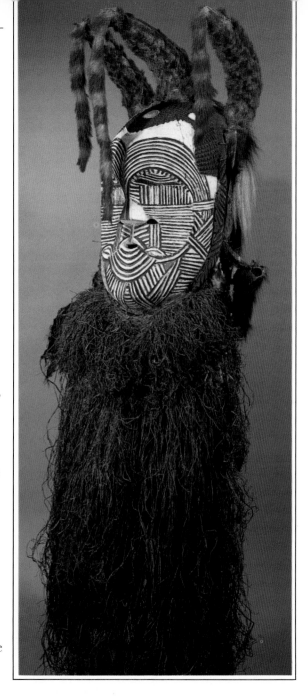

▷ **Batetela mask**

Wood, fur and fibre

OBJECTS MADE OF WOOD have a short lifespan in hostile conditions, and most of the tribal carvings we possess are relatively recent products which, however, reflect much older traditions. Materials such as fur and, in particular, fibre are fragile and perishable; so it is rare to find a mask of any age, such as this one, complete with all its trappings, and it gives an impression of African life and art that is much richer than can be gained from a mask seen in isolation. The fur headdress and fibre costume set off the intricate black-and-white patterning of the mask, which is characteristic of the Batetela and their Basongye neighbours in south-central Zaire.

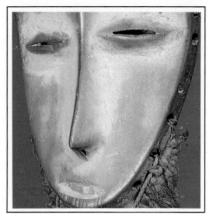

Detail

▷ **Balega mask**

Painted wood and fibre

THE BALEGA, OR WARENGA, live in eastern Zaire, in the tropical forest to the north-west of Lake Tanganyika. They dwell in small villages with no traditional political authority, but the Bwame society is a universal presence; unusually, all adults, women as well as men, belong to it. Consequently it is neither a secret society, nor a government, although the existence of many initiation grades does create a hierarchy of sorts, and also creates a demand for wood and ivory objects to serve as initiation badges and implements indicative of status. One such object was this mask with a concave face and a wonderfully elegant curving vertical that links the crown and the nose.

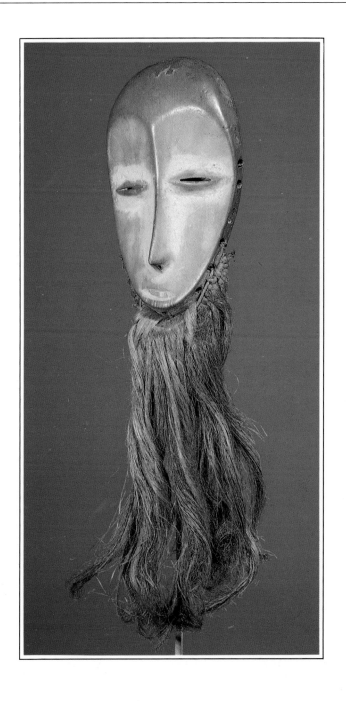

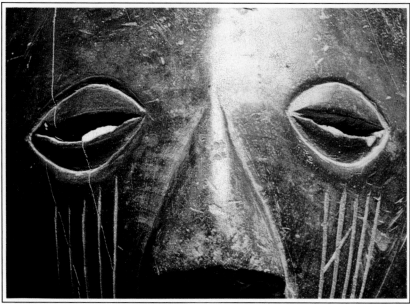

Detail

▷ **Baluba mask**

Wood

THE BALUBA OF south-eastern Zaire were formerly empire-builders who subdued many of their neighbours in the Lualaba basin; they dominated a series of large, if somewhat unstable states, from about 1500 to the late 19th century, when their power was broken by the Bajokwe. In spite of their wide geographical influence, there is a reasonably homogeneous Baluba style, which in figure carvings appears as a strong preference for rounded forms untramelled by surface decoration, and a tendency towards naturalism. The masks made by the Baluba are less naturalistic, and some do have extensive decoration in the form of dense, all-encompassing, white concentric lines. In this mask, however, the only details are scratchings representing scarification marks, and even the facial features are as simplified as they can be while still remaining recognizable.

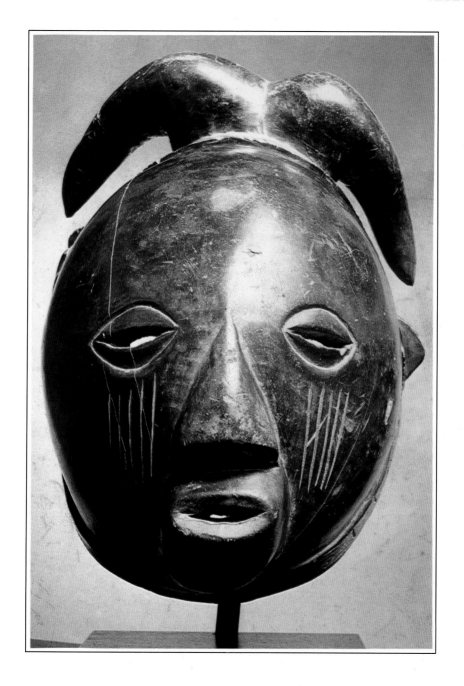

Detail

▷ **Masai shield**

Wood, hide and paint

MUCH OF EAST AFRICA was formerly the preserve of pastoralists such as the Masai, who ranged the grasslands of what are now Kenya and Tanzania with their cattle. As nomadic herders they despised farming and craft work, and had few personal possessions. But they were also formidable lion-hunters and warriors, raiding neighbours such as the Kikuyu; and what they did prize were personal ornaments and handsome, well-made weapons. This shield is constructed of cowhide with a wooden rim to strengthen and stiffen it; the pleasing abstract design, painted on the surface of the hide, approaches symmetry but varies from it enough to avoid monotony. However, it is not an arbitrary pattern, but the badge of the clan to which its owner belonged.

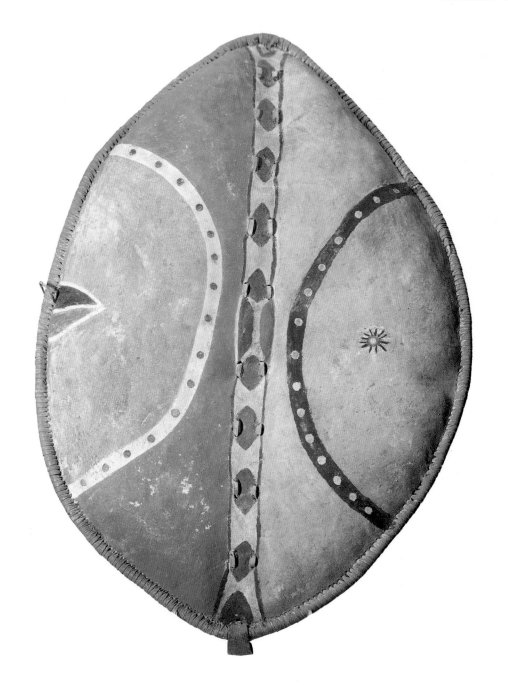

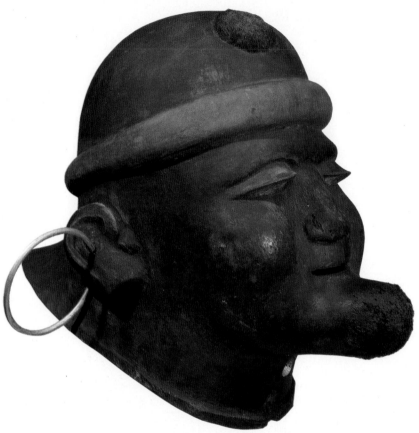

◁ **Makonde mask**

Wood

THE MAKONDE INHABIT the area of East Africa that lies between Lake Malawi and the Indian Ocean (that is, southern Tanzania and northern Mozambique). They probably migrated east from the Congo Basin, bringing with them skills that were already highly developed. Among the most striking Makonde carvings were helmet masks like the one shown here; its mixture of realism and caricature makes it easy to understand how, in recent times, Makonde carvers have so easily adapted their art to European tastes, settling in Dar-es-Salaam and producing skilful ebony sculptures for the tourist market. Even when making their traditional helmet masks, the Makonde set out to portray human types, including Europeans and Arabs. The head here is that of an Arab trader, with some hair attached to the top of the head and the protruding chin; chin and earring are nicely balanced to make the piece formally satisfying, but a strong sense of an individual personality also comes through.

ACKNOWLEDGEMENTS

The publisher would like to thank the following for their kind permission to reproduce the paintings in this book:

Bridgeman Art Library, London/British Museum, London: *8*, 9, 14, *15*, 16, 17, 21, 32, 33, 37, 38 *(also used on front cover, back cover detail and half-title page detail)*, 39, *40*, 41, *42*, 43, *44*, 45, 46, *47*, 48, *49*, 50, 52, *53*, 54, 55, 58, 60, 65, 71; /**Dr. Werner Muensterberger Collection, London**: 10, 11, *68*, 69; /**Josef Herman Collection, London**: 12, 13, 64; /**Private Collection**: *18*, 19, 20, 39, *72*, 73, *74*, 75; /**Musée de l'Homme, Paris**: *22*, 23; /**Museum of Mankind, London**: 24, 30, *31*, *56*, 57; /**Bonhams, London**: 25, 26-27, *76*, 77; /**Lance Entwistle Collection, London**: 28, 51, 61, *62*, 63, *66*, 67, 78; /**University of California Museum of Cultural History**: 29; /**Museum fur Volkerkunde**: 34, *35*; /**Rietberg Museum, Zurich**: 36; /**Horniman Museum, London**: 70

NB: Numbers shown in italics indicate a picture detail.

Every effort has been made to trace the copyright holders and we apologise in advance for any unintentional omissions. We would be pleased to insert the appropriate acknowledgement in any subsequent edition of this publication.